SURREALISM

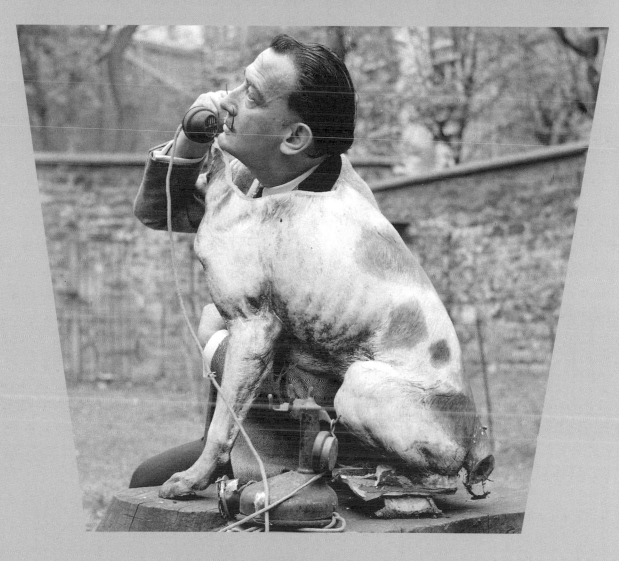

Anna Claybourne

www.heinemann.co.uk/library
Visit our website to find out more information about Heinemann Library books.

To order:
☎ Phone 44 (0) 1865 888112
📄 Send a fax to 44 (0) 1865 314091
💻 Visit the Heinemann bookshop at www.heinemann.co.uk/library to browse our catalogue and order online.

Produced for Heinemann Library by White-Thomson Publishing Ltd, Bridgewater Business Centre, 210 High Street, Lewes, East Sussex BN7 2NH.

Heinemann Library is an imprint of **Pearson Education Limited**, a company incorporated in England and Wales having its registered office at Edinburgh Gate, Harlow, Essex, CM20 2JE – Registered company number: 00872828 Heinemann is a registered trademark of Pearson Education Limited.

Text © Pearson Education Limited 2009.
First published in hardback in 2009.
The moral rights of the proprietor have been asserted.

Edited by Ruth Nason and Megan Cotugno
Designed by Mayer Media Ltd
Picture research by Amy Sparks and Ruth Nason
Originated by Chroma Graphics
Printed and bound in China by Leo Paper Products

British Library Cataloguing in Publication Data
Claybourne, Anna
 Surrealism. - (Art on the wall)
 1. Surrealism - Juvenile literature
 I. Title
 709'.04063

ISBN 978 0 431933 29 0 (hardback)
13 12 11 10 09
10 9 8 7 6 5 4 3 2 1

Acknowledgements
We would like to thank the following for permission to reproduce photographs:
Bridgeman Art Library **pp. 9** (Ludwig Museum, Cologne, Germany/Max Ernst/DACS), **11** (Art Institute of Chicago, USA/René Magritte/DACS), **15** (Jacques Prévert/DACS/ Archives Charmet), **17** (Israel Museum, Jerusalem, Israel/ René Magritte/DACS), **18** (Minneapolis Institute of Arts, USA/Yves Tanguy/DACS), **21** (Southampton City Art Gallery, UK/Roland Penrose), **24** (Musée National d'Art Moderne, Centre Pompidou, France/René Magritte/DACS/ Lauros/Giraudon), **27** (Masson, André /DACS), **31** (National Gallery of Art, Washington DC, USA/René Magritte/ DACS/Lauros/Giraudon); Corbis **pp. 7** (Estate of Marcel Duchamp/DACS/Burstein Collection), **8** (Bettmann), **19** (François Pugnet/Kipa), **33** (Salvador Dalí, Gala-Salvador Dalí Foundation/DACS, London), **34** (Herscovici, Brussels/ René Magritte/DACS/Christie's Images); Mary Evans Picture Library **p. 5** (Rue des Archives), **16**; Chris Fairclough **p. 25**; Getty Images **pp. 4** (Salvador Dalí, Gala-Salvador Dalí Foundation/DACS/ Chris Young/AFP), **28** (Claude Huston/Pix Inc./Time Life Pictures), **39** (Michael James O'Brien/AFP); iStockphoto **pp. 10**, **22** (John Woodcock), **35**; Kobal Collection **p. 23** (Buñuel/Dalí); Library of Congress **p. 6**; Mike Nason **p. 14**; Science Photo Library, **p. 38** (Sovereign/ISM); Topfoto **pp. 12 and title page** (Roger-Viollet), **13** (Meret Oppenheim/DACS), **20** (Marilyn Kingwill/ArenaPAL), w**36** (Marilyn Kingwill/ArenaPAL).

Cover photograph: Yves Tanguy: *Through Birds, Through Fire, But Not Through Glass* (1943), Minneapolis Institute of Arts, USA/Yves Tanguy/DACS/The Bridgeman Art Library).

We would like to thank John Glaves-Smith for his invaluable help in the preparation of this book.

Every effort has been made to contact copyright holders of material reproduced in this book. Any omissions will be rectified in subsequent printings if notice is given to the publishers.

Contents

Some words are printed in bold, **like this.** You can find out what they mean by looking in the glossary.

What is Surrealism?

The sculpture in the picture below is called *Lobster Telephone*. And that's what it is – a telephone that is partly a lobster. Does it surprise you, scare you, or make you laugh? Is it ugly, silly, strange, or beautiful? When the Surrealist artist Salvador Dalí created this work, he wanted to make people think about all these things.

More than real

The Surrealists were a group of artists and writers who got together in Paris in the early 1920s. Almost from the beginning, they had strong ideas about what they wanted to do. They named themselves Surrealists, based on "**surreal**", originally a French word, meaning "beyond real" or "more than real".

In one way, a lot of Surrealist art is very real-looking. It often shows realistic objects, people, and places. But they are grouped or altered in ways that make them look startling and unfamiliar. Men in suits

A Surrealist object like Salvador Dalí's *Lobster Telephone* is designed to make people think when they see it. How does it make you feel? You might immediately think about how you would use it. If this telephone rang, would you pick up the lobster part and hold it to your ear?

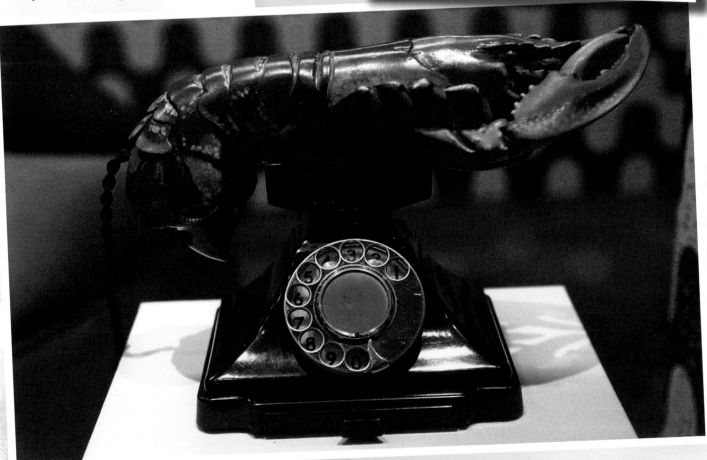

fall from the sky like rain. A woman has butterflies for eyes. A train steams out of a fireplace. All these are real, everyday things, but what is happening to them is strange, impossible, and dreamlike.

Dreams and the imagination

Many Surrealist paintings and sculptures show the type of things that might be seen in dreams. This is because the Surrealists were very interested in dreams, the imagination, and the **subconscious** – a deep, mysterious part of the mind that we are not normally aware of. For example, have you ever come out with the wrong word, which turns out to express your real feelings about something, when you were trying to be polite? Scientists think that things like this show your subconscious at work.

According to the Surrealists, feelings and thoughts in the subconscious were more important and true than everyday manners, traditions, and values. But people's subconscious feelings and thoughts were hidden behind their **rational** (sensible and reasonable) thoughts and actions. Dreams, poetry, and art, the Surrealists said, could give a glimpse of the subconscious, and help people to reach it.

First reactions

At first, many critics and members of the public found Surrealism shocking. In 1925 the Société des Gens de Lettres de France, a writers' organization, condemned the *"scandalous behaviour of the Surrealists"*.

Beyond art

Surrealism was an art **movement**, but it went far beyond paintings and sculptures. There are also Surrealist photographs, poems, plays, and films. The Surrealists saw themselves as a political movement, too, and had strong views on many things. And in everyday life, we still use the word "surreal" to mean bizarre, silly, unexpected, or absurd.

This book explores the work of the Surrealists, and their artistic aims and ideas. It shows how Surrealism came into being, and still has an influence today.

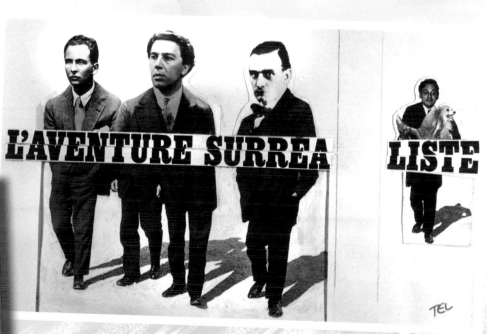

Four Surrealist writers are shown in this photomontage of "The Surrealist Adventure", from the 1920s. They are, from left to right: Louis Aragon; André Breton, the Surrealists' leader; Philippe Soupault; and Raymond Queneau.

How Surrealism began

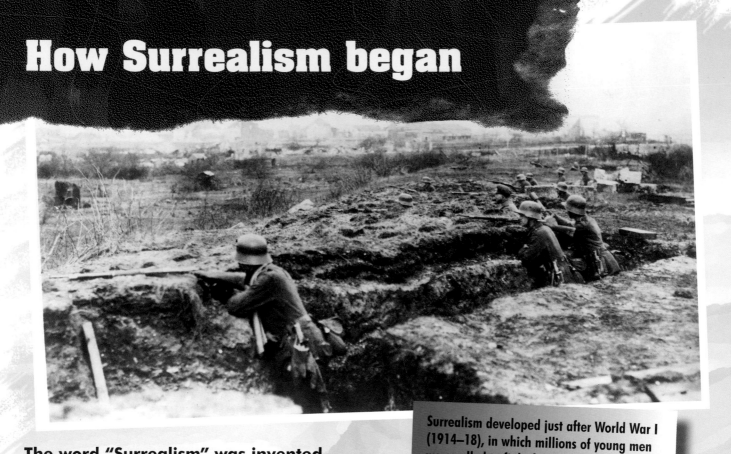

Surrealism developed just after World War I (1914–18), in which millions of young men were called to fight for their countries.

The word "Surrealism" was invented in 1917 by a French writer, Guillaume Apollinaire. He used it to describe ballets and plays. The Surrealist art movement had not yet begun, but its seeds had been planted. The art of the previous two centuries, the new science of **psychology**, and the horrors of World War I all helped to bring it about.

Romantic ideals: the 18th century

In the late 18th century, a movement known as **Romanticism** took over art, music, and literature. It was a reaction against the rise of scientific thought in the early part of the century. At that time, "romantic" did not just mean to do with love, as it does today. Romantic poets, artists, and composers wanted their work to portray strong emotions and the power of nature. Their ideas probably influenced the Surrealists' interest in the subconscious.

From real to unreal: the 19th century

Romanticism inspired artists to paint imposing natural landscapes and mythical scenes. But, by the beginning of the 19th century, some people felt that art in Europe had become traditional and unadventurous. Most art showed realistic, detailed landscapes, portraits, and still-life subjects.

From about 1850 some painters, such as Claude Monet and Pierre-Auguste Renoir, tried new methods – sketching outdoors, experimenting with patterns of light and shade, and building up pictures from blobs and dabs of paint. They became known as the **Impressionists**, as their paintings gave an "impression" of reality, as seen in a moment, rather than a detailed re-creation of it. Towards the end of the century, artists such as Vincent van Gogh and

Paul Gauguin became interested in summoning up emotions in their art, not just re-creating what the eye saw.

Dada

From 1914 to 1918 Europe was in the grip of World War I. Millions of young men died in the fighting. This terrible conflict made many people question the political and cultural values of the age, which they believed had let the war happen. In about 1916, in Zurich, Switzerland (a country not involved in the war), a group of artists began to rebel against the rules of art and society. They called their movement **Dada**. They wanted to destroy everything and begin again with chaos and mess. They created art from rubbish, for example, or performed on stage by making nonsensical, clashing noises and screams.

A new direction

Dada spread through Europe and other parts of the world, but after the war it began to fade away. Some of its ideas lived on, however. In the 1920s, Dada artists began to meet up with writers who were interested in the subconscious. They began to see the subconscious mind as a powerful creative force that could help people to see the world in a new, maybe better, way.

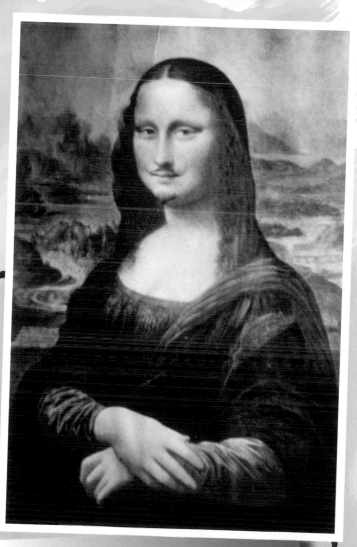

Some Dada artists made damaged, **defaced** versions of famous works of art. For example, Marcel Duchamp made a copy of the much-loved portrait *Mona Lisa*, painted by Leonardo da Vinci in 1503–6, and added a moustache and beard.

Try it yourself

Rework a classic

Try creating your own Dadaist work of art, like the one shown here, by altering a copy of a classic painting. Take a colour copy of a painting by a famous artist such as Leonardo da Vinci or John Constable, or find one on the Web and print it out. Then make your own changes. Add horns and snaggle teeth, tear it, cover it in stickers, or scribble all over it – it's up to you.

André Breton

As the Surrealist movement began to develop, a young French doctor and writer called André Breton became its leader. During World War I Breton worked as a **neurologist**, a doctor of the brain and mind. He was fascinated by the work of Sigmund Freud, who wrote about the importance of dreams and the subconscious. Breton kept records of his own patients' dreams, and wrote down the rambling things they said, in an attempt to learn about the subconscious.

Breton together with two Dadaist writers, Jacques Vaché and Philippe Soupault, explored the idea of the subconscious as a force in creative writing. They experimented with **automatic writing** – trying to go into a trance and write down whatever thoughts bubbled up from the deepest parts of the mind. Gradually, painters and sculptors also became interested in these ideas. In Paris, France, in the early 1920s, they formed a group around Breton, and began calling themselves the Surrealists.

Sigmund Freud

Sigmund Freud (1856–1939) was born in Austria. He became a neurologist, a doctor working with disorders of the brain, mind, and **nervous system**. He wrote many books about the importance of dreams and subconscious desires and feelings. He believed that subconscious desires were the driving force behind human behaviour. Freud also worked in the fields of psychology and **psychiatry** – the study of the mind and the treatment of mental illness. He thought that mental problems could often be solved by exploring the person's subconscious feelings. Freud's work changed the way that people thought about the mind, emotions, and why people behave as they do.

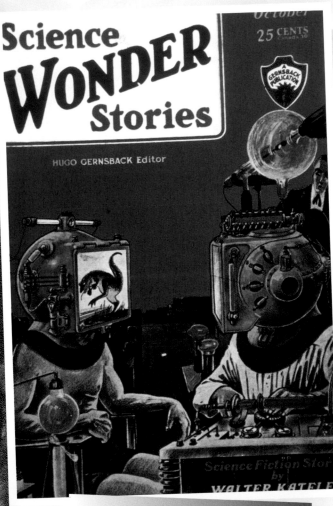

Ideas about the subconscious intrigued **science fiction** writers, too. This magazine cover from 1929 shows an illustration of a science fiction story called "Into the Subconscious". In the story, people were hypnotized and put in "memory helmets". Memories hidden in their subconscious were revealed on the screens on the front of the helmets.

A Surrealist manifesto

In 1924 Breton wrote the first Surrealist **Manifesto**, setting out the aims of Surrealism. (He wrote a second manifesto in 1929.) *"We are still living under the reign of logic,"* he wrote – but, he said, logic and reason were not enough. The truly important things were the imagination, the subconscious, dreams, and beauty. He went on: *"the marvellous is always beautiful, anything marvellous is beautiful, in fact only the marvellous is beautiful."* By "marvellous", he meant surprising, amazing, shocking, or startling.

The Surrealists also opened a head office, the Bureau for Surrealist Research, on Rue de Grenelle in Paris. There they could meet, discuss ideas, and show each other their work. In 1926 they opened their own gallery in Paris, the Galerie Surréaliste.

Who were the Surrealists?

In the early days, the Surrealists included German poet and artist Max Ernst, Italian painter Giorgio de Chirico, and American artist and photographer Man Ray. Later Surrealists included the great Spanish artist Salvador Dalí, Belgian painter René Magritte, Swiss artist and photographer Meret Oppenheim, and English artist Roland Penrose.

Sometimes Breton decided that certain artists should be banned from the group, or invited to join it. But as the influence of Surrealism spread, many artists around the world experimented with Surrealist ideas, whether or not they knew Breton and his friends.

Max Ernst's 1922 painting *Rendezvous of the Friends* features many of the Surrealists, including Ernst himself (front row, left), Robert Desnos (front row, far right), Philippe Soupault (back row, left) and André Breton (back row, with arm raised).

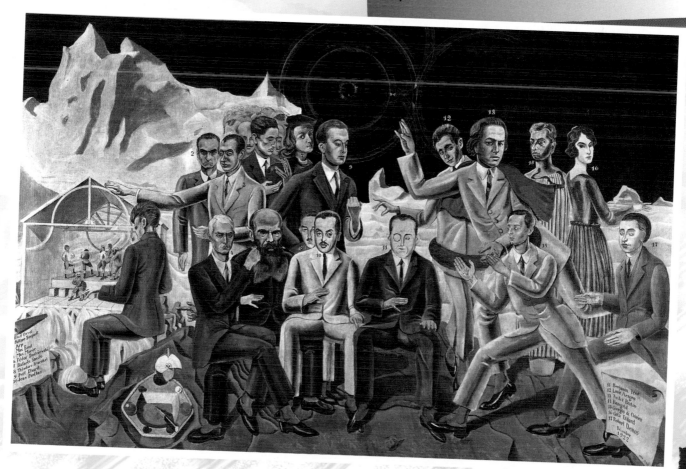

Strange meetings

*"As beautiful as the chance meeting, on a **dissecting table**, of a sewing machine and an umbrella".*

Written by a French poet, the Comte de Lautréamont (1846–70), the words quoted above bring together three objects that would probably not be found as a group in real life. To Lautréamont, such a surprising, strange combination was beautiful. The Surrealists agreed. They often quoted his words to explain what they were trying to achieve in their art.

The shocking Comte

The Comte de Lautréamont was actually just a pen-name. His real name was Isidore Ducasse. He is sometimes described as "an early Surrealist" – though he lived more than 50 years before the Surrealist movement began. His poetry is full of violent and bizarre descriptions, designed to shock the reader and reject a **conventional**, everyday view of objects and reality. Many people found his work horrific, but the Surrealists admired it deeply. Like Lautréamont, they wanted to break free from everyday expectations, routines, and conventions.

The shock of the strange

In the 1920s, Surrealist leaders such as André Breton and Max Ernst used Lautréamont's unusual idea of beauty to explain what Surrealist art should do. They said that paintings should bring random everyday objects together, outside their usual settings, to make people look at them afresh.

For example, when you see rubber gloves, for washing up and other cleaning jobs, you might ignore them, thinking only of their dull, everyday purpose. But a painting from 1914 by Giorgio de Chirico, called *The Song of Love*, shows an orange rubber glove pinned to a wall, along with a green ball and a carving of a head. This is intended to make the viewer see the rubber glove in a new way. It is a fascinating object, with its own shape and strange beauty.

What is beautiful?

The objects the Surrealists put in their paintings might not strike you as beautiful at first. They painted furniture, telephones, shoes, doorways, unremarkable rooms, vehicles, and household gadgets. These everyday things are not "pretty", like a country landscape or a vase of flowers. But that was the point. The Surrealists thought that reason, convention, and good taste stood in the way of the truth. Surrealist art should shock the viewer into looking at things afresh, and seeing their true beauty. Breton said, *"beauty will be convulsive or will not be at all"*. Convulsive means making you have a fit or writhe in agony.

A bizarre combination of objects, such as the train and the fireplace in *Time Transfixed* by René Magritte, can shock or surprise us, make us laugh, or confuse us. Using this method, the Surrealists hoped to cut through everyday normality to provoke feelings deep in the subconscious.

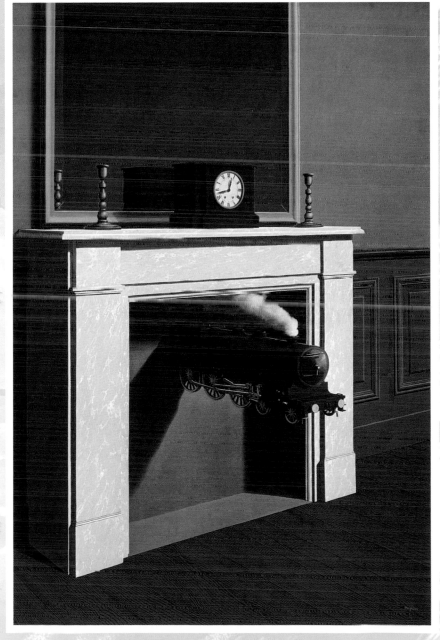

Try it yourself

Surreal still life

Set up a surreal still life by selecting two or three very different, unrelated objects and placing them somewhere unusual. You may find it hard to pick objects that aren't related in some way, because your brain is always looking for patterns and things that go together. You could try closing your eyes and picking up objects at random. When you're happy with your scene, paint a picture of it.

In 3D

It is easy to bring unrelated objects together in a painting, where anything can be shown. But some Surrealists tried to do the same in 3D – in sculpture. When they succeeded, they created some of the most famous and striking Surrealist art of all. Dalí's *Lobster Telephone* is a classic example (see page 4). In one way, it is nonsensical, pointless, and even silly. But it is also a real object, bringing the Surrealist sense of shock and strangeness into the real world. A 3D Surrealist object makes the viewer imagine and experience what it would be like to touch it, pick it up, and use it.

Ready-made art

Like *Lobster Telephone*, the best-known Surrealist sculptures are strange versions of familiar objects that we see and use every day. In fact, unlike traditional sculptures, which are carved from stone or cast in metal, many Surrealist sculptures are actually made of real everyday objects, changed or adapted in some way. A sculpture that is made of an already existing object is sometimes called a **ready-made,** or ready-made art. This name was first used by the Dada artist Marcel Duchamp. His ready-made work *Fountain* (1917) was made of a porcelain men's toilet urinal, turned on its side.

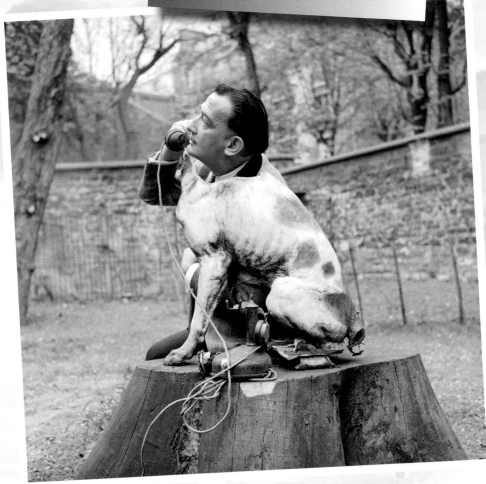

As well as experimenting with weird and wonderful ideas in his art, Salvador Dalí was an incredibly flamboyant person. He often wore a cartoonish moustache and elaborate clothes, and posed for comical or bizarre photos. In this portrait, taken in 1956, his fascination with telephones reappears as he poses with a statue of a headless dog, making himself look like a dog using a telephone.

A sense of touch

One great example of Surrealist ready-made sculpture is *The Gift*, by Man Ray. It is made of a clothes iron with a row of sharp tacks fixed along its underside. Of course, this immediately makes it useless as a clothes iron. At the same time, it seems shocking and powerful. Held like a normal iron, it would be a dangerous and frightening object.

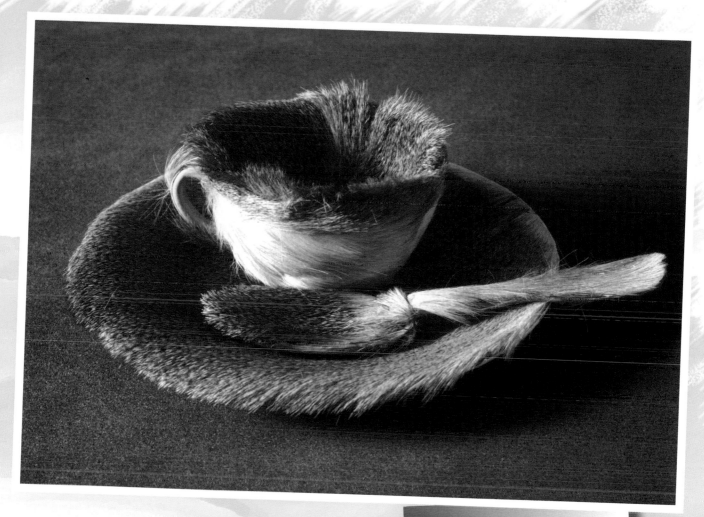

Another, perhaps even more famous, Surrealist sculpture is *Object (Fur Breakfast)*, created in 1936 by Meret Oppenheim. It's made of a teacup, a saucer, and a spoon, covered in fur. As with *The Gift*, the artist has changed the object to make it useless. At the same time, it may seem strangely frightening and powerful, as if it might be alive.

Meret Oppenheim herself named this sculpture from 1936 simply *Object*. André Breton gave it its more famous name, *Le déjeuner en fourrure*, which is usually translated as *Fur Breakfast* or *Breakfast in Fur*.

Your own ready-made

Can you think of a Surrealist object – an everyday object with an alteration that makes it useless, funny, or scary? For example, what changes could you make to a computer keyboard, a teapot, or a shoe, to turn them into Surrealist art? You could draw a picture of your idea, and even make it in 3D, if you have old objects that you can use.

Surrealist skills

If you look closely at Surrealist art, you will see that the Surrealists did not always use what we would think of as expert painting skills. Some did – for example, Salvador Dalí was a talented painter with a highly developed **technique**. But some other Surrealist painters, such as René Magritte and Giorgio de Chirico, used a much simpler, flatter style. The French poet and illustrator Robert Desnos even used a cartoon style. Not all the Surrealists trained at art school. Max Ernst, for example, studied philosophy, then dropped out of college before training himself as a painter.

Most Surrealist artists did not place much importance on how perfectly they could paint or draw an object. To them, art was about ideas. As long as a piece of art got its ideas across, it didn't matter if it was a drawing, a painting, a cartoon, or a ready-made object.

Collage

From the earliest days, the Surrealists found that **collage** was a good way to bring together unrelated objects to make strange, surprising images. Max Ernst loved collage, and often experimented with it. He said that it allowed *"the chance meeting of two remote realities on an unfamiliar plane"*. In other words, collage made it easy to combine images of unrelated things, in completely different styles or from different times. For example, a collage could combine black and white photos with colourful packaging designs, copies of old paintings, or three-dimensional objects and textures such as buttons, fur, or wood.

Try it yourself

Create a collage
Even if you don't like painting, or aren't very good at it, you can try making a Surrealist-style collage. Cut out photos, illustrations, and patterns from a wide range of sources. You could use old magazines, postcards, food packets, photos of yourself and your friends, and materials such as foil, cling film, or feathers. You can add words, too, cut from newspaper headlines or written by hand. Arrange the pieces to make a picture, and glue them in place.

The shapes, colours, or textures of materials may give you ideas for the subject of a collage.

Even better, collage was popular with small children. The Surrealists thought that children were more closely in touch than adults with dreams, **irrational** ideas, and the imagination. This was because children had not yet learned all the restrictive rules and customs of adult society.

Words in art

The Surrealists didn't stop at combining different images, textures, and shapes in their art. They were happy to add another, completely different kind of communication – words. Sometimes, they painted the title of a painting within the painting itself. Or they made whole pictures from words arranged in patterns. One example is *The Cacodylic Eye*, by the French artist and poet Francis Picabia. It shows an eye surrounded by graffiti-style names and slogans. (Cacodylic means poisonous or evil-smelling.)

Jacques Prévert was a writer who joined the Surrealists in the early 1920s, but later left the group. He created several Surrealist collages, such as *The Aeroplane* (1957), which combines the modern machinery of an airliner with plant and animal parts.

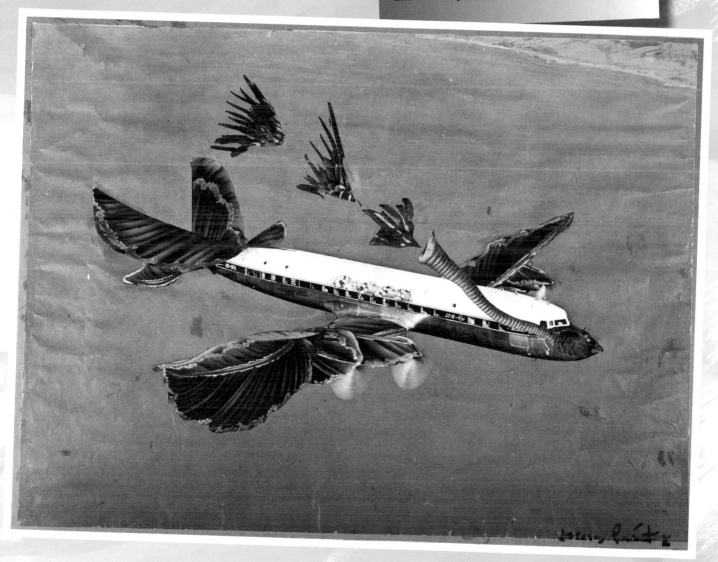

The world of dreams

You're in a strange house, filled with staircases that lead nowhere. Your best friend is there – and yet she's also a cat. Suddenly you can fly. What's going on? You're dreaming, of course! When we dream, our brains put together all kinds of images, ideas, and memories. The weird and wonderful world of dreams was very important to the Surrealists.

The subconscious set free

Sigmund Freud (see page 8) thought that dreams provided important clues about what goes on in the subconscious mind. He called dreams the *"royal road to the subconscious"*. When we are asleep, we can't decide what images pop into our heads. Our most deeply buried wishes and worries, and the things that matter most to us, can roam freely through our minds.

Impossible events

In dreams, things happen that cannot happen in real life. Being able to fly or float in the air is one example. You might dream that a car can drive up the side of a building, or that you can breathe underwater. An object might be completely the wrong size, or in the wrong place. These elements of dreams inspired the Surrealists to show impossible things happening in their pictures.

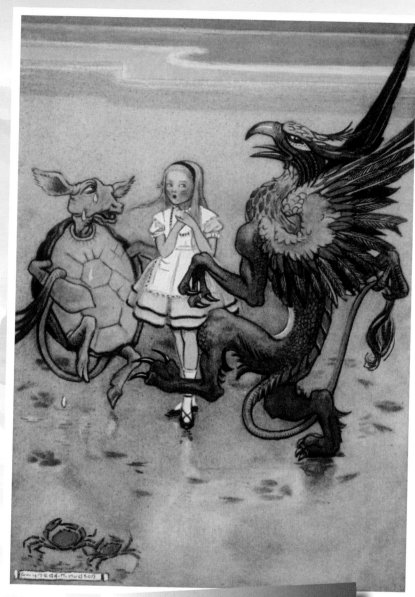

A 1922 illustration of Alice, the Mock Turtle, and the Gryphon, from *Alice's Adventures in Wonderland* by Lewis Carroll. Carroll wrote this children's book in 1865, long before the Surrealist movement, but it contained many surreal ideas and events, and many of the Surrealists admired it.

A painting created using ideas like these shocks and startles you. Yet it may also plunge you into the calm, unquestioning state of mind that you have when you dream. As André Breton wrote, *"The mind of the man who dreams is fully satisfied by what happens to him."* Dreams, he said, are full of *"a welter of episodes so strange that they could confound me now as I write... And yet I can believe my eyes, my ears."* In other words, when we dream, we accept all the bizarre, impossible events our brains come up with. We don't even realize we are dreaming until we wake up. The Surrealists wanted people looking at their works to open their minds and reach a similar state of acceptance.

Try it yourself

Keep a dream diary
Dreams are usually clearest in your memory when you first wake up – then they start to fade. Keep a pad of paper and a pen by your bed, so that you can jot down what you dreamed about as soon as you're awake. Choose an interesting dream and see if you can paint a scene from it.

Fears and nightmares

Of course, dreams aren't just about odd, puzzling, or unlikely events. We also have nightmares, when our deepest fears seem to come to life. Some Surrealist paintings explore this, depicting terrifying scenes that might feature in nightmares. For example, *Danger on the Stairs* (1928) by Pierre Roy shows a large snake slithering down the stairs of an apartment block.

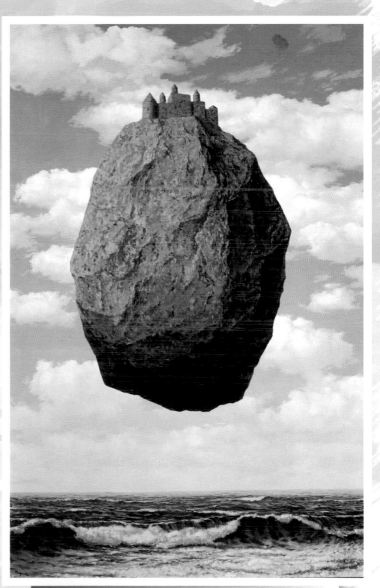

Castle in the Pyrenees, painted by René Magritte in 1959, shows a typically dreamlike Surrealist scene, with a massive rock and castle floating impossibly above a sea with breaking waves.

Strange visions

In some Surrealist paintings people or objects are **distorted**. They change shape, stretch, or appear to melt. This might happen in a dream, or in a **hallucination**, a strange vision that can happen when someone is awake. Some illnesses, and some medicines and drugs, can make people have hallucinations.

The Persistence of Memory by Salvador Dalí shows clocks that seem to have melted. They lie soft and floppy, draped over a tree branch, and dripping over a ledge. Another Dalí work, *Sleep*, shows the face of a sleeping man – but instead of having a body, his neck tails away into a drooping sock shape, propped up with sticks. These images don't just show dreamlike scenes. They also **evoke**, or bring about, feelings and sensations. *Sleep* is intended to evoke the dreamy, floating feeling of falling asleep, when you no longer feel your body attached to you.

Alien worlds

Surrealist painter Yves Tanguy painted bare, moonlike landscapes, with peculiar creatures in them. Some of these look like blobs, others like strange machines – yet they all seem to have personalities. Tanguy's paintings often appear to tell a story, but as with a vague, complicated dream or nightmare, it is hard to pin down exactly what the story is.

Colours and shapes

Spanish painter Joan Miró painted things that he thought he had seen in

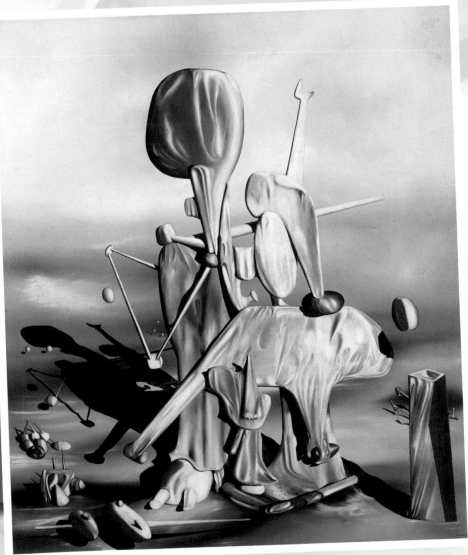

This picture by Yves Tanguy, painted in 1943, is called *Through Birds, Through Fire, But Not Through Glass*. It seems to include many recognizable shapes and textures – but when you look more closely, everything is bizarre, alien-looking, and unfamiliar.

hallucinations. After moving to Paris in 1920, he could afford very little food, and had visions brought on by hunger. Staring at an empty wall made him see dancing colours and shapes. *"I would sit for long periods looking at the bare walls of my studio, trying to capture these shapes on paper,"* he explained.

Miró's pictures are often made up of a chaotic mixture of leaping shapes and patterns. Some of the shapes are geometric or **abstract** (meaning that they do not represent real objects). Others are distorted or cartoonish versions of real things, such as birds, fish, and guitars. André Breton greatly admired Miró as *"the most Surrealist of us all"*. Breton believed that Miró's paintings came close to capturing the workings of the subconscious.

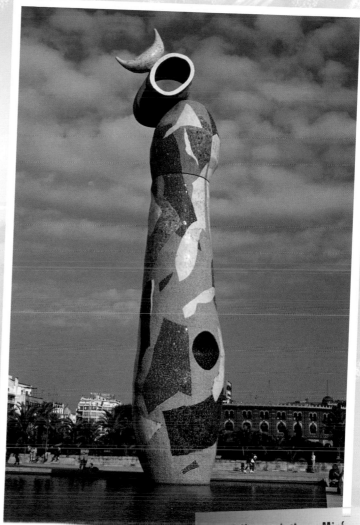

As well as paintings, Miró created buildings and sculptures in his recognizable colourful, playful style. This sculpture, called *Woman and Bird,* is in Barcelona, Spain.

What are dreams and hallucinations?

Studies show that when we sleep, we go through several periods of "Rapid Eye Movement" (REM) sleep, when our eyes move and flicker around while closed. We dream most during REM sleep. However, scientists are not yet sure what causes dreams or what purpose they serve. Some have suggested that we dream as the brain sorts out our memories, deciding which to store and which to delete.

Hallucinations happen when the brain is disturbed, for example by an illness, lack of sleep, lack of food, or certain medicines and drugs. The disturbance sparks off signals that tell the brain it can see things which, in fact, the eyes are not seeing.

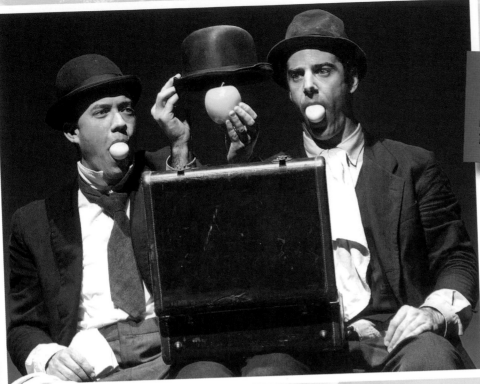

They are dressed for work, blank-faced, looking all the same – almost like clones. But Magritte always introduces a startling, dreamlike element, which makes his "clones" look ridiculous. In *Golconde*, the suited, hatted men drop from the sky like rain. In *The Son of Man*, a huge green apple blocks out the whole of the suited man's face. And in *Not to be Reproduced*, a man looks into a mirror which, instead

The right way to behave

Have you ever had a dream about arriving at school and suddenly realizing, to your horror, that you're still wearing pyjamas? Dreams like this are very common. They highlight the difference between the private person you are inside and the person you show to the outside world, by your clothes and behaviour in public. You feel embarrassed in the dream, because people are not supposed to show their private selves in public.

The Surrealists were very interested in the difference between outward appearance and inner life. They saw that the rules, customs, and manners of society control and hide who a person really is.

Men in suits

Belgian Surrealist René Magritte often painted men in neat black suits and bowler hats. They seem to represent rules, reason, and rational thought.

Dreams matter

In the 1924 Surrealist Manifesto, André Breton wrote: *"I have always been amazed at the way an ordinary observer... attaches so much more importance to waking events than to those occurring in dreams."* René Magritte agreed, saying: *"If the dream is a translation of waking life, waking life is also a translation of the dream."* To the Surrealists, it was wrong to think that only people's waking hours were "real life". The dream world was the most real world of all.

of a reflection of his face, shows his back. Magritte seems to exaggerate and mock the way that outward appearances hide the truth about people's inner lives and feelings. Describing *The Son of Man*, he said: "*Humans hide their secrets too well.*"

Breaking free

The Surrealists wanted to give more power and freedom to the subconscious, which they felt was so often reined in by customs, conventions, and correct behaviour. In a painting by English Surrealist Roland Penrose, *The Conquest of the Air*, a blank-eyed, robotic figure has a skull made up of bars, like a cage. Trapped inside is a wild-looking eagle, its eyes alive and vivid. The eagle is like the subconscious mind, held inside a blank, dull outer shell.

The Conquest of the Air, painted by Roland Penrose in 1938, shows something wild, natural, and untameable, trapped inside a calm, blank outer appearance — and it is struggling to escape. The painting's title could mean that the wild inner life of the subconscious, the imagination, and dreams is conquered and trapped. Or it could mean that the subconscious is about to escape its cage, and take over.

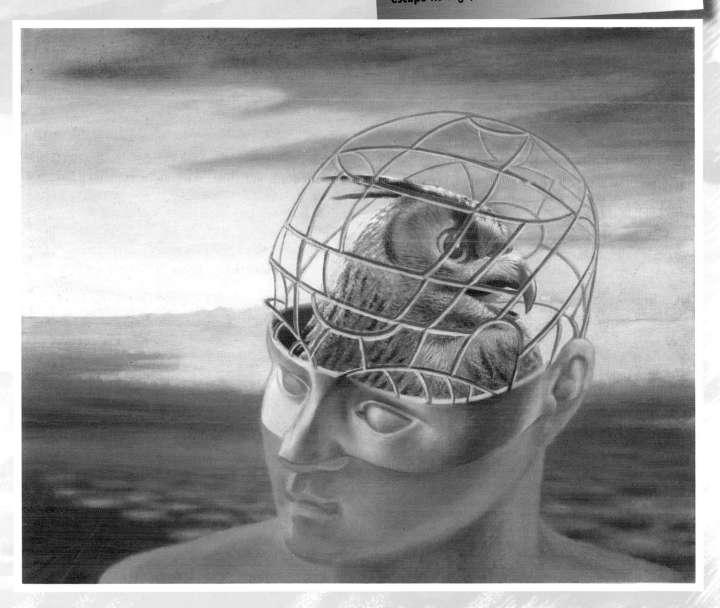

The bizarre body

A set of drawers open out of a woman's stomach and legs. Another woman has two S-shaped holes in her back, making her look like a violin. The lines on an old man's face are made of tiny bricks. In many Surrealist artworks, strange, impossible things are shown happening to the human body.

The body and the self

The Surrealists wanted to use art to shock people and make them think. Showing strange versions of the human body was a great way to do this. We all have a body, so the human shape is very familiar to us. We think of our body as being our self. So, when we see a body that is distorted, or changed, or has parts missing or added, it feels shocking and alarming.

For example, Max Ernst painted several pictures showing people with no heads. In *Octavia*, Roland Penrose painted a woman's shoulders, head, and arms, with the rest of her body missing. And in *Winged Domino – Portrait of Valentine*, he showed a woman's face with clusters of butterflies instead of a mouth and eyes.

The changing body

During the 20th century, many artists, not just Surrealists, began to experiment with changing the human body when they painted it. For hundreds of years, it had been traditional for artists to show people as realistically as possible, in portraits and sculptures. Modern artists wanted to do something different. For example, Spanish artist Pablo Picasso, who knew many of the Surrealists, painted women with their eyes, noses, and mouths in odd places on their faces. He was partly inspired by African masks and other traditional art that used non-realistic body shapes and proportions. In statues by the English sculptor Henry Moore, bodies were smoothed and rounded into blob-like forms. Moore was moving as far as possible from portraying realistic body shapes, while still making them recognizable.

Artists began to create portraits combining views of the person seen from several different angles. This style, developed by Picasso and others, was called **Cubism**.

What makes a person?

By taking away parts of bodies, the Surrealists asked: how much of a body needs to be present for us to see a person? In one picture, *The Dangerous Hour*, by Czech artist Toyen – also known as Marie Cermínová – an eagle-like bird has feet that are a pair of folded human hands. The hands/feet rest on sharp, broken glass. The bird immediately seems somehow human.

In Man Ray's picture *Observatory Time*, a giant pair of red lips floats in the sky above a dark hill. It's just a pair of lips, yet it seems as though a huge whole person is watching over the world. So, even when we see only a tiny part of a human body, we can't help but recognize and identify with it.

A Surrealist film

In 1929 two Spanish Surrealists based in Paris, Salvador Dalí and Luis Buñuel, made a famous Surrealist film called *Un Chien Andalou* (meaning "An Andalusian Dog" – Andalusia is a region of Spain). The 16-minute film has no plot but shows a series of bizarre and shocking things happening to people. For example, one scene shows a hand with ants crawling out of a hole in its palm.

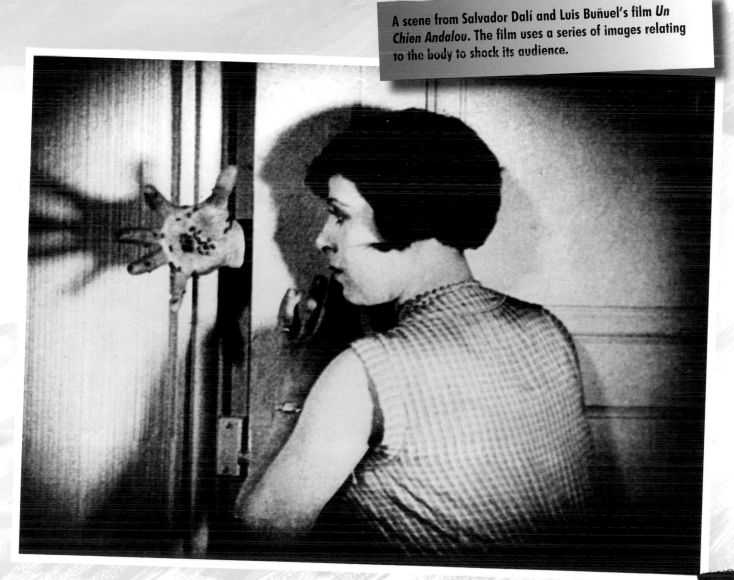

A scene from Salvador Dalí and Luis Buñuel's film *Un Chien Andalou*. The film uses a series of images relating to the body to shock its audience.

Bodies and clothes

Is the true reality of a person their body alone, or their body with clothes on? Or is it both?

Magritte's painting *Red Model* shows a pair of boots – but halfway down, they change into human feet. Magritte was very interested in the way that clothes hide the body, and the body hides the insides. *"Everything we see hides another thing,"* he said. His boots show the body inside coming to the surface.

Bodies and objects

The first half of the 20th century, when Surrealism took off, was a time of amazing inventions and new technology. Cities were expanding, and telephones, cars, and cinema were becoming things that everyone could use and experience. Surrealist artists explored these themes by combining the human body with an artificial or technological object. Man Ray made a sculpture called *Indestructible Object*, by attaching an image of a human eye to the needle of a **metronome** – a device for making a regular, tick-tock beat. In both painting and sculpture, Salvador Dalí showed a woman who was also a chest of drawers – the drawers opened out of her legs and torso.

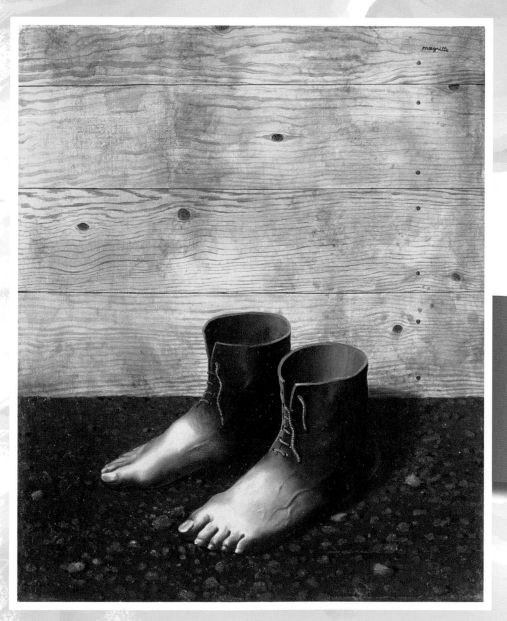

Like many Surrealist images, Magritte's *Red Model* seems to make you feel something. The tough boots are made to protect the feet from the sharp, stony ground. But the feet are warm and alive, and you can almost feel the gravel under them.

Robot power

This was also the era of the first **robots**. The word "robot" was invented by the Czech playwright Karel Capek for his 1920 science fiction play, *RUR (Rossum's Universal Robots)*. In this play, the robots are artificial slaves, built to do boring, tiresome work for humans. They rebel against their human masters and take over the world.

Another work from around 1920, *The Spirit of Our Time* by Austrian Dada artist Raoul Hausmann, reflects the idea of technology invading human life. It is a wooden head with artificial and technological items fixed onto it and drilled into it – dials, knobs, numbers, wires, and a tape measure. In one way, Dada and Surrealist artists were fascinated with machinery and technology. But many saw technology as dangerous, especially if it might one day take over and destroy what they believed was the essence of human beings – the ability to dream and imagine.

Try it yourself

A new face

The easiest way to experiment with Surrealist body art is to create a new version of your own face. Take a photo of yourself, and make a collage by adding other objects to it, or pictures cut out of magazines. For example, you could replace your eyes with buttons or coins, or pictures of fruit, animals, or machinery parts.

Make your portrait as surreal as you can, but still recognizable as you.

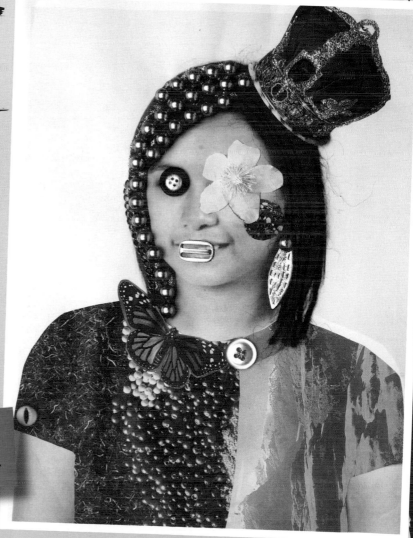

Automatic art

Surrealist leader André Breton thought that the best art and the most useful ideas came from the subconscious mind. Thinking, reasoning, and making decisions only got in the way. So Breton and others tried to find ways to let the subconscious take over and create art by itself. This process is often called **automatic art.**

Automatic writing

Being writers, Breton and his friend Philippe Soupault tried automatic writing. They tried to empty their minds of all thoughts, and wrote down whatever came into their heads, as fast as they could. Breton recalled: *"By the end of the first day of the experiment, we were able to read to one another about fifty pages obtained in this manner."* Breton and Soupault published an automatic novel, *The Magnetic Fields*, in 1920, as well as several other automatic writings. What do you feel when you read the extract below from Breton's 1924 work *Soluble Fish*? How nonsensical does it seem?

"I heard it said in my youth that the smell of hot bread is intolerable to sick people, but I repeat that the flowers smell of printer's ink. The trees themselves are only more or less interesting minor news items: a fire here, a derailment there..."

A game of consequences

You may have played a game called Consequences. One person writes the first sentence or part of a story at the top of a piece of paper, folds away what they have written, and hands the paper to the next person, who adds the next part of the story, and so on. Finally, the whole story is read out. It is possible to play a similar game by taking turns to draw the parts of a person. This was one method that the Surrealists tried, for creating automatic art that was not under any one person's control.

Make a group image

Try making an automatic artwork with friends. One person draws a head and neck at the top of a tall piece of paper, and folds down the top of the paper so that only the bottom of the neck shows. The next person adds the top part of a body, from neck to waist, including the arms, and folds down the paper so that only the bottom of the waist shows. The next person adds the bottom of a body, from waist to ankles, and folds down the paper so that only the ankles show. The next person draws some feet. Then unfold the paper to see the picture you have created.

Doodles, scribbles, and mess

During the 1920s French Surrealist André Masson became obsessed with creating automatic art. He would go without food and sleep to try to weaken his conscious mind and stop his reason from controlling him. Then he would draw by letting a pen wander across a piece of paper. Later he tried throwing glue and sand at a **canvas** to make random shapes and sketching around these. To some, Masson's works might look like scribbles and mess, but the Surrealists saw them as pure, true art, as they were made without rational thoughts or decisions.

To make works such as this one, called *Personnage Animal* (1933), André Masson splashed glue and sand onto a canvas, and then painted the images that came into his head when he looked at the random results. He often ended up with hints of wild animals and natural forces, such as fire and water, leaping and darting around.

Smoke, splatters, and splats

Automatic writing and drawing worked well for some Surrealists, but the artists still had to use their hands to hold a pen, paint, or glue – so, in some ways, the conscious mind was still in control. To move away from this, some artists tried using other things to make art for them. For example, Austrian Wolfgang Paalen developed a way of using the swirling of smoke and soot to make marks on paper. Other artists used damaged and torn paper, and let paint drip or run to make messy patterns.

Ernst's experiments

One of the most experimental Surrealists was the former Dada artist Max Ernst.

Inspired by children's art, he investigated many methods of making art without involving his own plans and decisions. He tried **frottage** – making pencil rubbings of interesting textures such as a grainy wooden floor, and looking at the results to see what shapes they reminded him of. So, he explained: *"the author assists, indifferent or passionate, at the birth of his work and watches the phases of its development."*

Another method Ernst used, called **grattage**, involved scraping and digging at dried paint to make patterns. He also tried pressing wet paintings together or squashing them with textured material such as foil, to make the paints spread out, blur, and blend.

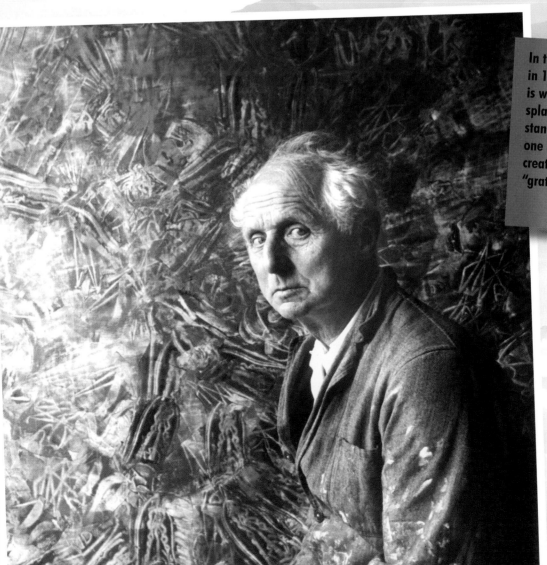

In this photo taken in 1961, Max Ernst is wearing a paint-splattered jacket and standing in front of one of the works he created using the "grattage" method.

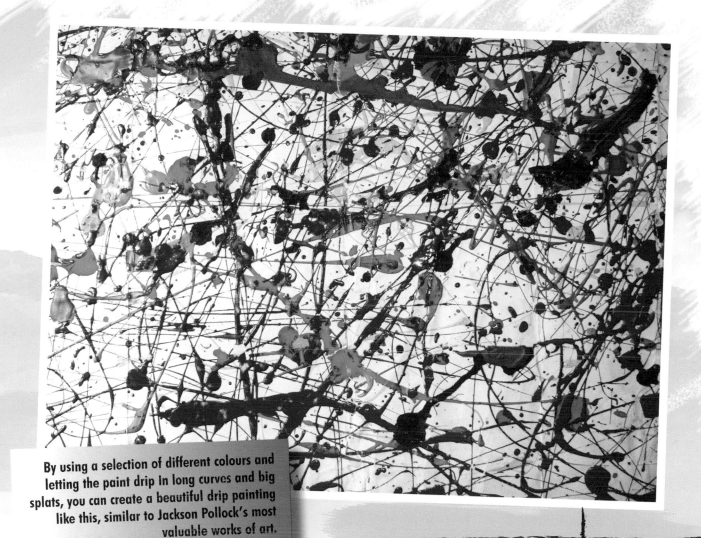

By using a selection of different colours and letting the paint drip In long curves and big splats, you can create a beautiful drip painting like this, similar to Jackson Pollock's most valuable works of art.

Drip paintings

One of Ernst's most important experiments resulted in his **drip paintings**. Like many artists, Ernst fled Europe during World War II (1939–45) and ended up in the United States. There, he showed a group of young artists a new technique he had developed. He made a hole in the bottom of a can of paint, hung the can on a string, and let the paint dribble out to make splashes and drips on a flat canvas. Ernst's experiments may have influenced an American artist, Jackson Pollock, who uscd a similar method in the 1940s and 1950s. Pollock's drip paintings are now among the best-known and most valuable art in the world.

Try it yourself

Splatter art

Your own drip paintings are great fun to make, but you'll need a big open space where it doesn't matter if you make a mess (outside might be easiest), and an adult to help you. Place a large piece of paper or card flat on the ground. Tie a plastic drinks bottle to a string and hang it from an overhead beam or tree. Fill the bottle with runny paint, and then make a small hole in the bottom with pointed scissors. Push, swing, or sway the bottle to and fro on its string, to dribble paint splats and drips all over the paper. When you've finished with one colour, try adding another.

What is real?

"Surreal" means "beyond real" or "more than real", but what does "real" mean? The Surrealists were obsessed with this question. Which is more real: the everyday world, or the world of dreams and the imagination? Is a picture less real than the object it shows? Or is it more real, since it comes from the artist's mind?

Where is reality?

The Surrealists used all kinds of tricks to make people think about the idea of "reality". Some Surrealist pictures seem to escape from or spill over their frames, blurring the line between the world of the picture and the "real world". In other pictures illusion is used to make us see two things at once, so that "reality" seems to change before our eyes. Some artists painted the process of painting, so that parts of their pictures appear still unfinished.

Reaching out

Two Children are Menaced by a Nightingale is a work by Max Ernst, which seems to cross from its own world into ours. A painted landscape with four figures overlaps the canvas and spreads onto the frame. A shed-like building, made of wood, sticks out of the picture. On it stands what looks like a man holding a girl, and he is reaching towards a real, three-dimensional doorbell fixed to the frame. There is also a three-dimensional wooden gate that opens out of the picture, towards us. It seems that we could walk into the painting, or that the people in it might escape from it.

Crazy titles

The titles of many Surrealist works of art do not seem to match what we see in them. Max Ernst's *Two Children are Menaced by a Nightingale* seems to contain three children, and the nightingale in it is hardly scary! It is so small that you may not even notice it if it were not mentioned in the title. And why is Magritte's painting of boots that become feet (see page 24) called *Red Model*? By using an odd title like this, the artist adds another layer of confusion. What should we pay more attention to: the painting, and how it makes us feel, or the title, and what it tells us to think?

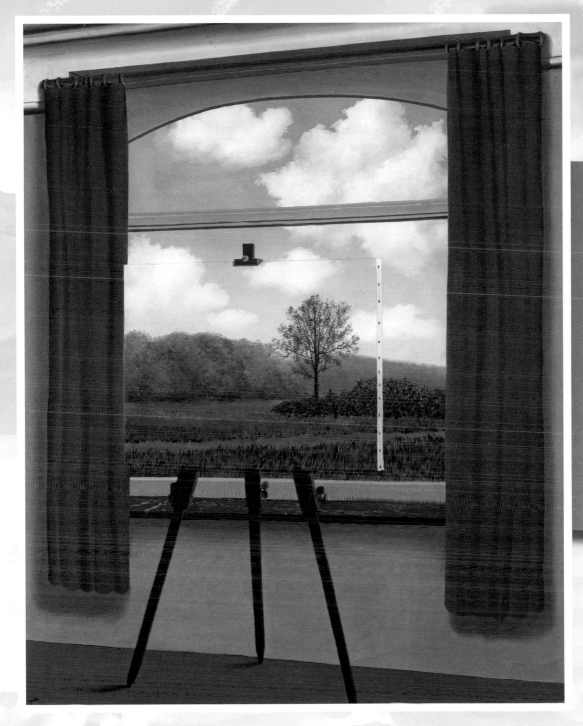

Layers of life

In his works, René Magritte often included an image of an image, such as a painting on an easel or a reflection in a mirror, to make up part of the scene. *The Door to Freedom* shows a broken windowpane, with a pleasant landscape beyond it. On the floor lie the broken pieces of glass – and they are not glass at all, but pieces of a painting showing the exact same scene. In *Euclidean Walks* and *The Human Condition*, paintings on easels exactly match and blend into the whole scene. Magritte is reminding us that nothing we see is ever the ultimate reality. Everything – even the images that our eyes send to our brains when we see things – is a representation of something else.

Optical illusions

An optical illusion is an image that misleads your brain, makes it see something that isn't there, or tricks it into seeing a picture in two ways. Some examples are shown here.

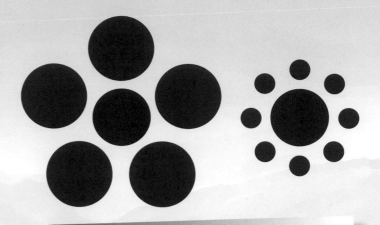

Which of the two red circles is bigger? In fact, they are both the same size, but your brain tells you they are not. This is because your brain does not just see what is there. It comes to conclusions by comparing what it sees with the things round about.

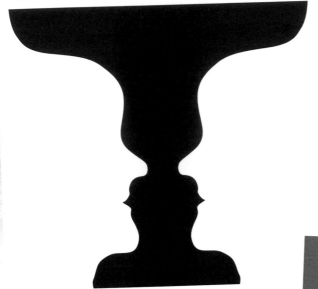

Do you see a vase or two faces? Salvador Dalí made paintings based on this type of optical illusion.

Salvador Dalí was fascinated with optical illusions, and used them in some of his works. For example, *Slave Market with Disappearing Bust of Voltaire* shows several figures under an archway. But if you look at the picture as a whole, the shadows and shapes seem to form a **bust** (a statue of the head and shoulders) of Voltaire, a famous French writer. *Apparition of Face and Fruit Dish on a Beach* is a painting of a beach and landscape but, looking at it in a different way, you can see a fruit bowl, a face, and a dog.

Dalí called this way of painting the "**paranoid-critical**" method. The name was inspired by his understanding of **paranoia**, a medical condition that causes people to see or believe in things that aren't there. Surrealist leader André

Freud's view

Sigmund Freud (see page 8) remarked about Dalí's paintings: *"It is not your unconscious mind which interests me, but rather your conscious mind."* He meant that however hard the Surrealists tried, they could not avoid the fact that their conscious minds did play a big part in their art. Dalí's paranoid-critical paintings especially involved a lot of conscious thought and deliberate planning.

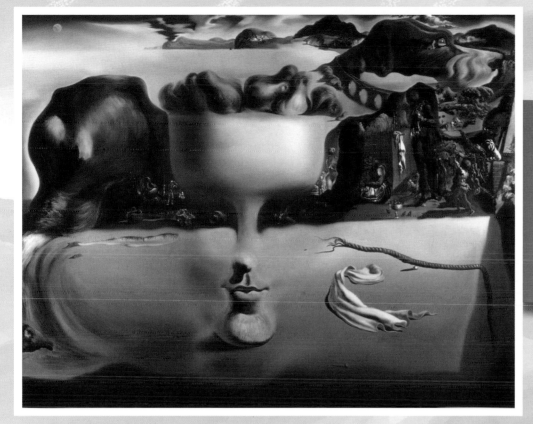

The title of this painting by Salvador Dalí is *Apparition of Face and Fruit Dish on a Beach*. Try looking at the picture as a landscape, with a beach, rocks, and hills in the distance. Then look differently and see what other images you can find in the painting.

Breton admired the paintings because they revealed the working of the subconscious mind – for example, the way we automatically see faces in random patterns. Our minds try to force what we see to form familiar patterns that make sense to us. What we see in an optical illusion is truly "surreal", or beyond real, because it is not actually there in reality.

Painting in action

The Czech painter Toyen created a different kind of illusion when she painted *At the Château Lacoste*. It shows a wolf crushing a bird against a wall with his paw. But only the paw is painted realistically, to look 3D. The rest of the wolf's body becomes a sketch, drawn on the wall itself. Magritte had painted a similar picture called *Attempting the Impossible*, showing a man and a woman. While the man is all there, the woman standing next to him is incomplete, and the man is in the process of painting her. At first, with these paintings, we see a picture of an animal or a person, and accept it as a living thing. Then the artist reminds us that it is just an illusion, under his or her control.

Escher's illusions

Artists other than the Surrealists have explored the world of fantasy and optical illusions, using a highly finished style to make the unreal seem real. They are sometimes called **Magic Realists**. One of the most famous is the Dutch artist M. C. Escher. Using optical illusion, Escher created images that look very real but show impossible objects and events, such as never-ending staircases and waterfalls. His work *Drawing Hands* goes one step further than the works of Magritte and Toyen. It shows two hands, each of which is holding a pencil to draw the other!

Objects and words

In the early 20th century, **linguistics**, the study of language, became an important science. Scientists tried to find out how it is that certain words mean certain things, and how we understand words. This was an important inspiration for the Surrealists. They could use the way words carry meaning to add impact to their works.

Magritte's *The Treachery of Images*, with its famous inscription, "This is not a pipe". When people asked the artist about it, he is said to have answered: *"Just try to stuff it with tobacco! If I were to have written on my picture 'This is a pipe' I would have been lying."*

Is this a pipe?

The Treachery of Images by René Magritte is a clear, simple painting of a pipe. Beneath it, though, Magritte has added the French words "Ceci n'est pas une pipe" – "This is not a pipe". At first, this might seem a simple denial. But actually the words are true. What we see is not a pipe, but a painting of a pipe. It is simply a set of paint marks and smears on a canvas. The word "pipe" is not a pipe either. These things merely make us think of a pipe. They create an imaginary pipe somewhere in our brain.

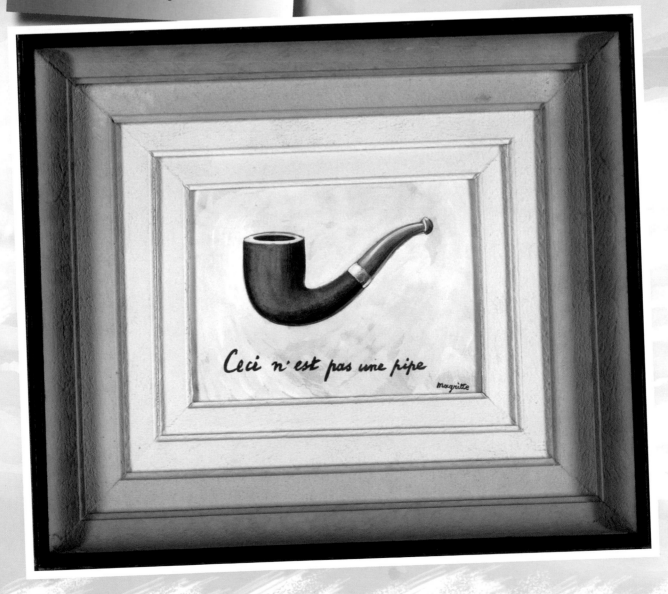

Ceci n'est pas une pipe

magritte

Magritte is pointing out that many, many layers of meaning and understanding lie between our inner mind and the outside world. In the version of the picture shown on page 34, he drew in several frames, each one inside the next, to emphasize this point.

Ferdinand de Saussure

Swiss scientist Ferdinand de Saussure (1857–1913) is often called the father of modern linguistics. While teaching at the University of Geneva in Switzerland, he developed a theory of language that is still important today. Among other things, Saussure pointed out that the connection between most words and what they describe is **arbitrary**, or random. A word does not actually mean anything in itself. It only means something because we decide it does, and the meanings of words can change over time. For example, "mouse" used just to mean an animal — now it means a piece of computer equipment too. Saussure inspired artists and others to think differently about language and to explore the meanings of words in art.

The Key to Dreams

Magritte explored this idea again in a painting called *The Key to Dreams*. In four sections, which look like small blackboards, are four pictures: a bag, a penknife, a leaf, and a sponge. Under each picture is a description. The sponge is called "The sponge", the bag is named "The sky", the knife is "The bird", and the leaf is "The table". The painting invites us to try to make sense of the labels, but it is impossible. Instead, we may think about why things have names, and how words make us see things.

Try it yourself

A picture with labels
It's easy to make your own painting or collage and add words to label the objects in it. Do you want to give the objects their "correct" names or the wrong names? You could try cutting out lots of words from an old magazine, then selecting them at random to add to the picture.

The sky

Experiment with finding words that have as little relation as possible to the thing they are used to label.

Surrealism's influence

From the start, Surrealism included poetry, novels, film, and photography, as well as paintings and sculptures. As far as the Surrealists were concerned, any method or material could be used to explore and express their ideas. And since Surrealism first began, in the 1920s, it has spread far and wide, and influenced even more forms of art.

The spread of Surrealism

The first Surrealists saw themselves as belonging to a special club. As time went on, however, Surrealist thought spread to all kinds of artists and writers, even if they did not consider themselves "Surrealists".

World War II forced many Surrealist artists to move away from Europe, and this helped to spread their ideas around the world.

The **Theatre of the Absurd**, a movement in European drama from the 1940s to the 1960s, developed from Surrealism. Absurd plays include *Rhinoceros* by Eugène Ionesco, in which, one by one, the people of a small town turn into rhinoceroses. In *Waiting for Godot* by Samuel Beckett, two men wait for the mysterious character Godot, who never arrives.

A scene from Samuel Beckett's famously surreal play *Waiting for Godot*, written around 1950. Although Godot never arrives, two ragged strangers, Pozzo and Lucky, do turn up during the play. Pozzo pulls Lucky along on a rope, like a dog on a lead.

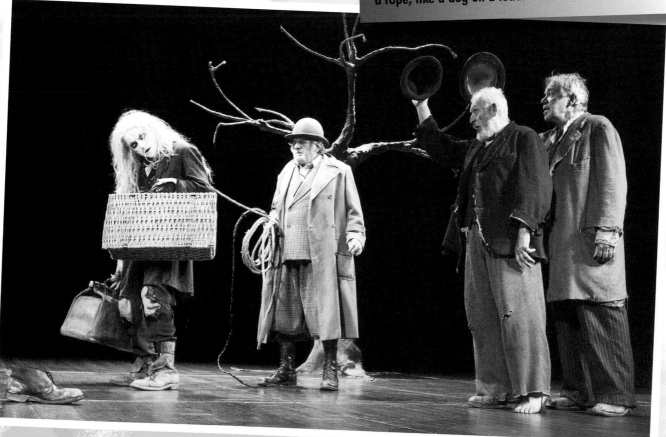

The Surrealists' interest in the subconscious was also linked to another kind of writing, called "stream of **consciousness**". This method of writing tried to recreate the flow of thoughts running through someone's mind, ignoring the rules of correct sentence style and punctuation. It was used by great novelists, such as Virginia Woolf and James Joyce.

Surreal music

Free jazz musicians let their playing wander wherever it will, beyond the conventions of musical scales, key, and rhythm. In some ways this is similar to the Surrealists' automatic writing and drawing. Some pop bands have been influenced by Surrealism, too, including the Beatles. Their guitarist, singer, and writer John Lennon wrote several songs with surreal lyrics. For example, the Beatles song *I am the Walrus* contains lines such as "Semolina pilchard, climbing up the Eiffel Tower" – which could describe a typical Surrealist painting.

Surrealism in the modern world

Surrealism was originally intended to shock, by breaking through conventional customs and rules. But now the styles and themes of Surrealism have become so well-known and popular that they are a normal part of everyday culture. Many comedy shows rely on surreal elements, such as bizarre, absurd events or dreamlike sequences. You can find hints of Surrealism in jokes, fashion design, and even advertising slogans. Surrealist paintings, especially by Dalí and Magritte, are more popular than ever. They are among the best-selling art posters, and can be seen in millions of homes as well as in art galleries around the world.

Stream of consciousness

This excerpt from James Joyce's book *Ulysses*, published in 1922, is an example of stream-of-consciousness writing. Like Surrealist writing, it tries to access the inner workings of the mind. Compare it with the automatic writing on page 26. Do the pieces make sense to you in different ways?

"...the night we missed the boat at Algeciras the watchman going about serene with his lamp and O that awful deepdown torrent O and the sea the sea crimson sometimes like fire and the glorious sunsets and the figtrees in the Alameda gardens yes and all the queer little streets and the pink and blue and yellow houses and the rosegardens and the jessamine and geraniums and cactuses..."

What happened to the Surrealists?

The Surrealist group that formed in Paris in the 1920s continued in various forms for decades. André Breton carried on managing the movement until his death in 1966. He lived in the United States and Canada for some years, but wherever he was, he gathered Surrealist artists together. He had strict rules of membership, and sometimes threw people out of his club if he did not like their political or religious beliefs. For example, Salvador Dalí was only an official member of Breton's Surrealist group for a small part of his life. He joined in 1929, but Breton banned him in 1939 because of Dalí's support for the new Spanish **dictator** General Franco.

Whether they were in or out of the group, many of the great Surrealist artists had long careers. Salvador Dalí, René Magritte, Man Ray, Roland Penrose, Max Ernst, Meret Oppenheim, Joan Miró, and many others continued working and making Surrealist art into the 1960s, 1970s, and even later.

Surreal science

The Surrealists asked some very big questions. What is consciousness, and what is the subconscious? How do humans interpret objects, words, and images and make them into meaning inside their heads? What makes a human being, and what makes a machine? These topics may not always be at the forefront of art today, but they are huge topics for modern science. For example, scientists are still studying the problem of consciousness, what exactly it is, and whether machines as well as humans could have it.

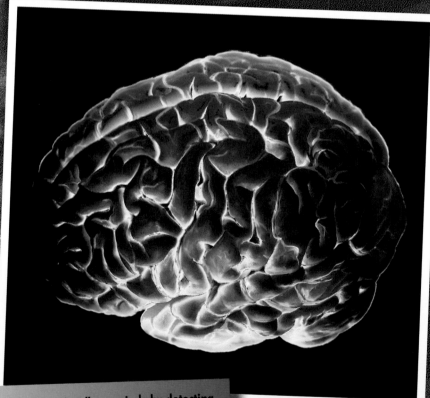

Modern brain scanners can now "see into" our minds by detecting which parts of the brain are active when we do different things. In this false-coloured scan, orange has been used to highlight the parts of the brain that are used when reading.

Surrealist art today

The modern art of the 21st century owes much to the Dada and Surrealist movements. It is now normal for artists to show shocking scenes, to make distorted, altered images of the human body, and to create sculptures using ready-made objects. Some artists today are still thought to follow a Surrealist path. The leading U.S. artist Matthew Barney is sometimes compared to the Surrealists, for his films and sculptures featuring collections of unrelated objects, costumes, and events, and bizarre materials such as tapioca and jelly.

This photo of Matthew Barney was taken during the filming of his 1995 work *Cremaster 4*. Here he is wearing face make-up and false ears to give him an alien or half-animal appearance.

Try it yourself

A modern art video

If you have a video camera, or even a videophone, you can make your own surreal modern art video. It can contain anything you can think of. Some modern art films have shown people standing totally still for the whole film. Or you could film yourself wearing odd costumes or masks, squeezing jelly in your hands, or making peculiar sculptures out of random objects.

Lives of the artists

André Breton (1896–1966)

Born in Normandy, France, André Breton trained as a doctor and psychiatrist. While working in a hospital in Nantes during World War I, he met and was inspired by Jacques Vaché, a young writer who opposed the rules of society and art. Vaché died in 1919, but Breton went on to found the Surrealist movement in Paris. In 1924 he wrote the first Surrealist Manifesto. He formed several Surrealist groups, sometimes inviting new members to join, or banishing old ones. He remained a leading figure in Surrealism until his death.

Max Ernst (1891–1976)

Born in Germany, Max Ernst decided to become a painter, although he had no art training. After fighting in the German army during World War I, he joined the Dadaist group of artists, and then, in the 1920s, became a member of the Surrealists. Ernst constantly experimented with and developed new forms of art, and inspired and influenced many other artists.

René Magritte (1898–1967)

René Magritte, often seen as one of the most typical Surrealists, was born in Belgium. His skill at drawing led to an early career as a designer. When he began painting, his work was mocked, so in 1927 he moved to Paris and made friends with the Surrealist group. He later returned to Belgium and became separated from the Surrealist group, but his work continued to explore Surrealist themes, as well as helping to inspire other art movements such as Pop art.

Giorgio de Chirico (1888–1978)

The painter Giorgio de Chirico was born in Greece to Italian parents, and later lived in Italy and France. Many of his early works, from 1910–20, anticipated the Surrealist ideas that André Breton wrote down in the early 1920s. De Chirico influenced many other Surrealist artists, and was closely involved with the first Surrealist group formed in Paris in 1924. However, he later turned to other styles of art.

Salvador Dalí (1904–89)

Born in Catalonia, Spain, Salvador Dalí became one of the most famous and flamboyant of all the Surrealists, though he eventually fell out of favour with Surrealist leader André Breton. Dalí showed an early flair for drawing, and studied art in Madrid. He impressed several great artists, such as Picasso and Miró, and became involved with the Surrealists in the late 1920s. His many works include drawings, paintings, sculptures, and films such as *Un Chien Andalou*, made with Luis Buñuel. Breton banished Dalí from the Surrealist movement in 1939 for not condemning the far right-wing leaders Hitler and General Franco. But Dalí insisted that he himself was the essence of Surrealism. He continued working into the 1980s.

André Masson (1896–1987)

André Masson was born in France, grew up in Belgium, and studied art in Brussels and Paris, where he joined the Surrealists. He is famous for his experiments with automatic art, involving drawing in a trance and making art from random patterns of sand and glue. Like many artists, he escaped World War II by going to North America, but later returned to France and continued to make art.

Roland Penrose (1900–84)

English Surrealist Roland Penrose grew up near London and studied architecture, but then became a painter. From 1922 to 1936 he lived in France, where he was influenced by Max Ernst and became involved with Surrealism. After returning to England, he became a leading figure in the art scene, organizing exhibitions of works by Surrealists and other modern artists. He also created many Surrealist paintings, drawings, and sculptures of his own.

Joan Miró (1893–1983)

Joan Miró was a Spanish artist with a unique style. He moved to Paris in 1920, and was admired by André Breton and the other Surrealists for his artistic recreations of hallucinations. Although he worked with some of the Surrealists, especially Max Ernst, Miró refused to become an official member of the group and eventually returned to Spain. He experimented with many art forms, including painting, sculpture, murals, and architecture.

Man Ray (1890–1976)

Man Ray was the adopted name of Emmanuel Radnitzky, an American Surrealist artist born in Philadelphia, USA, to Russian parents. He trained himself in painting and drawing, but later, influenced by Dada artist Marcel Duchamp, he began making ready-made sculptures. Ray moved to Paris in 1921, and was part of the Surrealist group from its beginnings. As well as sculpting and painting, he developed new techniques in Surrealist photography.

Meret Oppenheim (1913–85)

Meret Oppenheim was a German-born Swiss artist, photographer, and sculptor. In the early 1930s she moved to Paris to study art, and met Surrealists such as Man Ray. She was involved with the Surrealist movement throughout her art career and is best remembered for her sculpture of a fur-covered cup and saucer, *Object*.

Surrealism timeline

1899 Sigmund Freud's book *The Interpretation of Dreams* is first published in Germany. It will become an important influence on the Surrealists.

1914 World War I begins.

Giorgio de Chirico paints his famous pre-Surrealist work *The Song of Love*.

1916 André Breton meets writer Jacques Vaché while working in a hospital in France.

The Dada art movement begins in Zurich, Switzerland.

1917 French writer Guillaume Apollinaire coins the word "surreal".

1918 World War I ends.

1919 Jacques Vaché commits suicide, but leaves a strong impression on André Breton.

1920 André Breton and his friend Philippe Soupault publish their novel *Les Champs Magnétiques* (*The Magnetic Fields*), a result of their automatic writing experiments.

1921 Influenced by Dada artist Marcel Duchamp, Man Ray makes his sculpture *The Gift*.

1922 Irish writer James Joyce's novel *Ulysses* is published.

1924 André Breton writes the first Surrealist Manifesto.

The Surrealist movement is officially launched, with members including Breton, Max Ernst, Man Ray, Robert Desnos, and Philippe Soupault.

The Surrealists open a head office in Paris.

La Révolution Surréaliste (*The Surrealist Revolution*), a Surrealist review (a kind of magazine), is launched and runs until 1929.

1925 The first official Surrealist exhibition, *La Peinture Surréaliste*, opens in Paris, featuring works by several Surrealists including André Masson, Man Ray, and Joan Miró.

1926 Surrealists open the Galerie Surréaliste in Paris.

1929 René Magritte paints one of his most famous works, *The Treachery of Images* (also known as *Ceci n'est pas une pipe*).

Spanish artist Salvador Dalí joins the Surrealist movement.

Salvador Dalí and Luis Buñuel make the Surrealist film *Un Chien Andalou*.

1931 Salvador Dalí paints *The Persistence of Memory*, one of the most famous of all Surrealist works of art.

1933 *Minotaure*, a Surrealist magazine edited by André Breton and Pierre Mabille, is launched in Paris and runs until 1939.

Adolf Hitler comes to power in Germany. His policies lead to World War II.

1936 Dalí creates his famous sculpture *Lobster Telephone*.

Swiss Surrealist Meret Oppenheim makes the famous Surrealist work *Object* (also known as *Fur Breakfast*)

1938 A major Surrealist art exhibition, the *Exposition Internationale du Surréalisme*, takes place in Paris.

1939 Following the Spanish Civil War (1936–39), right-wing dictator General Francisco Franco comes to power in Spain.

Salvador Dalí is thrown out of the Surrealist group for his political views and support for Franco.

World War II begins.

1941 André Breton, Max Ernst, and Marcel Duchamp go to North America to escape the war in Europe.

1945 World War II ends.

1946 Breton returns to Paris and continues leading the Surrealist movement.

1966 Death of André Breton.

1967 Death of René Magritte.

1968 An exhibition at the New York Museum of Modern Art, entitled *Dada, Surrealism and their Heritage*, celebrates the works of Dada and Surrealist artists.

1974 The Dalí Theatre Museum, dedicated to the work of Salvador Dalí, opens in Figueres, Spain.

1976 Death of Max Ernst.

Death of Man Ray

1978 The Hayward Gallery in London shows an exhibition entitled *Dada and Surrealism Reviewed*.

1983 Death of Joan Miró.

1989 Death of Salvador Dalí.

1998 The Musées Royaux des Beaux-Arts de Belgique in Brussels, Belgium, puts on an exhibition of Magritte's work to commemorate the 100th anniversary of his birth.

Glossary

abstract in art, including little that is recognizable or realistic, but being made up of shapes, colours, or lines

arbitrary random or meaningless, not chosen for any reason or on any particular side

automatic art attempting to allow the subconscious to control the creation of art, instead of letting reason or rules play a part

automatic writing attempting to write without conscious thought, by trying to empty the mind before writing down random words and ideas

bust statue of the head and shoulders of a person

canvas piece of canvas (heavy cotton fabric) stretched over a wooden frame and used for painting on

collage work of art made by sticking a variety of materials to a surface

consciousness awareness of one's own thoughts and feelings

conventional normal, sensible, and following all the well-known rules and values, or conventions, of society

Cubism early 20th-century art movement in which images were broken down into geometric shapes, and subjects such as faces could be shown from various different angles at the same time

Dada art movement that began in 1916, in which artists tried to break down and attack previous art forms and aimed to make art from chaos and destructive acts

deface to damage or destroy something, such as a work of art, by changing its appearance

dictator ruler who has absolute power and controls his or her subjects by force

dissecting table table on which scientists dissect, or cut up, the things they are studying, such as plants or animals

distort to change the shape of something, for example by stretching or squashing it

drip painting painting made by allowing paint to drip from a can to make random patterns

evoke to bring something to mind or recreate a feeling of something

free jazz type of modern music that the player makes up as he or she goes along, in which any notes or rhythms can be used

frottage way of making pictures by holding paper over a patterned or bumpy surface and rubbing over it with a pencil or crayon

grattage way of making art by scraping and gouging at a painted surface

hallucination type of imaginary vision experienced while awake

Impressionists group of 19th-century artists who created pictures that give an "impression" of a scene, atmosphere, or feeling, instead of trying to recreate it exactly

irrational not rational, not controlled by reason, logic, or clear thinking

linguistics study of language and how it works

Magic Realism 20th-century art movement featuring a very clear, detailed style of painting or drawing, but often depicting nonsensical or impossible situations

manifesto document containing a set of ideas or rules for a group or club to follow

metronome device used by musicians, when practising a piece of music, to help them keep to the right speed and rhythm. It is set to tick at a chosen speed and number and pattern of beats.

movement style or approach to art practised by several artists in a particular period, and sometimes in a particular place

nervous system body system that includes the brain and nerves. It carries messages around the body and links the brain to the other body parts.

neurologist specialist in the branch of medicine that deals with the brain, mind, and nervous system

paranoia type of mental illness that makes people experience and believe in unreal feelings about themselves

paranoid-critical method of painting used and named by Surrealist artist Salvador Dalí. It involved painting pictures that could be seen in more than one way.

psychiatry branch of medicine that deals with illnesses of the mind and emotions

psychology study of the human mind and how it controls behaviour

rational sensible, logical, and reasonable

ready-made work of art that is made from an object that already exists, such as a telephone, an iron, or a teacup

robot automatic machine designed to do human tasks. Some robots are also built to look like humans.

Romanticism 18th-century movement in literature, art, and music, involving an interest in the power and beauty of nature and individual feelings and actions

science fiction literature with a theme of science, technology, or outer space, often set in the future

subconscious deep, mysterious part of the human mind of which a person is not normally aware. Sometimes it is referred to as "the unconscious".

surreal word from the French meaning "beyond real" or "more than real"

technique particular method or special skill used in making any kind of art

Theatre of the Absurd style of drama that developed in the 1940s and 1950s, featuring bizarre, surreal events, such as people turning into animals

Find out more

Useful websites

To see any work of art that is mentioned but not shown in this book, use Google Image Search (images.google.com) and type in the name of the artwork and the name of the artist.

General sites on art

www.tate.org.uk/kids/
The Tate Gallery's children's page, with lots of information on art of all kinds. The site features games that let you build your own artworks on-screen, so you could try using these to make a Surrealist image.

http://library.thinkquest.org/J001159/index.htm
"All About Art" site, with pages on many different art styles, including Surrealism. There are also links to the websites of many art museums.

www.princetonol.com/groups/iad/lessons/middle/for-kids.htm
"Princeton Online: Just for Kids", a large art site for children, with lots of useful links to help you to explore Surrealism and Surrealist artists.

www.kidzworld.com/quiz/4808-quiz-whats-your-artistic-style
Take this quick quiz to find out what kind of art your personality makes you suited to. Or you could try guessing which answers a Surrealist would give to the quiz questions!

www.nga.gov/kids/kids.htm
Children's site from the National Gallery of Art, Washington, D.C., USA. There are lots of interactive features that allow you to make your own art, as well as fascinating information on many artists and art movements.

A site on Surrealism

http://s4.brainpop.com/artsandmusic/artconcepts/surrealism/preview.weml
A fascinating animated introduction to Surrealism. The BrainPop site charges a fee to subscribe, but you can register for a free 5-day trial to view this movie.

More books to read

Surrealism (Art Revolutions), by Linda Bolton (Belitha Press, 2000)

Surrealism (Eye on Art), by Hal Marcovitz (Lucent Books, 2007)

Imagine That! Activities and Adventures in Surrealism, by Joyce Raimondo (Watson-Guptill Publications, 2004)

Internet-linked Introduction to Modern Art, by Rosie Dickins (Usborne Publishing, 2004)

Modern Art (Off the Wall Museum Guides for Kids), by Ruthie Knapp and Janice Lehmberg (Davis Publications, 2004)

Salvador Dalí and the Surrealists: Their Lives and Ideas – With 21 Activities, by Michael Elsohn Ross (Chicago Review Press, 2003)

The Mad, Mad, Mad, Mad World of Salvador Dalí (Adventures in Art), by Angela Wenzel (Prestel, 2003)

René Magritte (Getting to Know the World's Greatest Artists), by Mike Venezia (Children's Press, 2003)

Famous Artists: Miro, by Antony Mason (Watts, 2007)

Other artists to research

You may enjoy finding out about some of the less well-known Surrealist artists that we were unable to fit into this book – and about other artists who contributed to or influenced Surrealism. Here is a list of names to look up in art books or on the Internet.

Eileen Agar

Hans Arp

Leonora Carrington

M. C. Escher

Frida Kahlo

Conroy Maddox

Roberto Matta

Henry Moore

Paul Nash

Pablo Picasso

Jackson Pollock

Dorothea Tanning

Places to visit

These museums and galleries contain a range of interesting Surrealist exhibitions and works:

Tate Modern
Bankside
London SE1 9TG
UK
www.tate.org.uk/modern

The Scottish National Gallery of Modern Art and Dean Gallery
75 Belford Road
Edinburgh EH4 3DR
Scotland, UK
www.nationalgalleries.org/visit/page/2:118:4

The Museum of Modern Art (MoMA)
11 West 53 Street (between Fifth and Sixth Avenues)
New York, NY 10019-5497
USA
www.moma.org

The Art Institute of Chicago
111 South Michigan Avenue
Chicago, Illinois 60603-6404
USA
www.artic.edu/aic

Centre Pompidou
Place Georges Pompidou
75004 Paris
France
www.centrepompidou.fr

Index